THE BELT

This evening, I bent down to reach for my left-over chimichanga in the fridge when a powerful explosion detonated in my lap, just north of the "crotchal region."

My initial assessment was that I was suffering from either a burst appendix or a possible terrorist attack on the man sack.

Then I reached down and discovered the disjointed remains of my belt.

All of its parts had blown independently of each other, as if to say, "Fuck this!" before orchestrating a coordinated release.

I wanted to believe it died of natural causes, but the crime scene suggested suicide.

Dearest belt, I'm sorry. A life in the trenches finally robbed you of your will to exist.

Thank you for your quick and effortless release, both in times of anticipation and countless emergencies. I remember the time I forgot you at home and a gust of wind pants'd me in the grocery store. A reminder of your significance, my unsung hero.

You died with the normal holes that came with you, as well as the bonus holes I drilled into you because Del Taco was just too close to my house.

If you're chillin' in Belt Heaven, say hi to my dad's belt. You two know my ass *really* well. Stay gold, pony boy. Message received.

TOOTHLESS

REAL STORIES, REAL QUICK

TOOTHLESS

ISBN: 978-1-7374553-5-6

Cover Design:
Jolie Clemens
www.jolieclemens.com

Printed in the United States of America.

 To my mom, Miriam.
She *loved* a good story!

CONTENTS

ACKNOWLEDGMENTS

To Jerry Seinfeld and Larry David, thank you for creating the show that inspired my love of stories about nothing. The chapter-naming convention of this book was done in tribute to my favorite series of all time, Seinfeld.

To my trusted and talented friend, Jolie Clemens. YOU were the "magic sprinkles" that coached these stories into shape and crafted artistry to the jacket. Thank you for your gifted insight, honesty, support, and encouragement!

TOOTHLESS

Toothless is a riotous and all-too-candid collection of REAL-LIFE events. Intended as a "bathroom reader," Toothless' thirty-one stories will keep its reader company with a new and amusing account every day for an entire month.

The book's honest, comical, and sometimes earthy depictions include a wide range of actual events. From a ferocious sneeze that triggered the bodily function of a stranger in "The Sneeze," to the dog who wouldn't take no for an answer in "The Buddy"; from a man who used fast food as a weapon in "The Bacon Cheeseburger," to an insect who watched the author pulverize his own crotch in "The Fly"; and from a moving tribute to a trusted friend in "The Belt," to a childhood that was transformed by an act of dental malpractice in "The Toothless," you'll agree, "You can't make this shit up!"

The vivid and descriptive storytelling will make you feel you've witnessed each episode firsthand. *Toothless* delivers the laughs, and you'll rush to share them! So have a seat, hit the fan, and pick a chapter. It'll be quick!

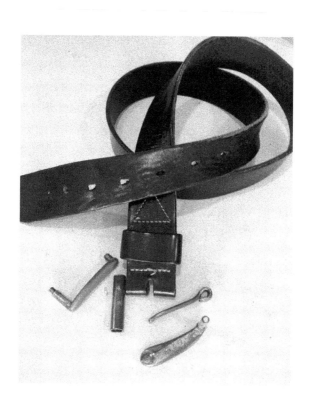

TOOTHLESS

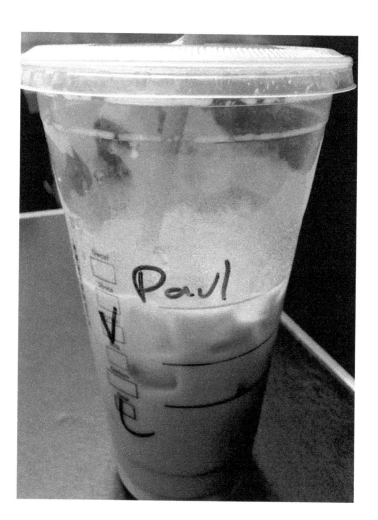

THE RAUL

For the record, my name is Paul.

"Grande Iced Vanilla Latte for Raul?"

The barista's call is met with no immediate response from the crowd of anxious Starbucks patrons. I am a part of that crowd.

A couple minutes pass.

"Grande Iced Vanilla Latte for RAUL!?"

Again, no takers.

Another minute passes and you can feel the rising tension in the crowd.

"I have a Grande Iced Vanilla Latte for RAUL!?"

The heads of my fellow caffeine addicts began to swivel, disdainfully looking around for this Raul character.

At this point I'm thinking to myself, "C'mon, Raul, get your shit together and pickup your damn drink so they can start working on my Grande Iced Vanil – Oh no way."

In the same instant, the frustrated barista thunders like the Alphorn blower in a Ricola commercial:

"RAAAAAAAAAA-OOOOOOOOOOL!!"

For a split second I debated asking "oh, do you mean Paul?"

Instead, I baby-stepped my way forward from the group in shame, with every set of eyeballs in that building glaring through my Raul Martinez skin, grabbed my cup, and said "Muchas gracias."

THE POPCORN

I blame my dad. He's the one responsible for passing down the "ass gene" that embarrassingly produced a shocking *lack* of seat-meat on this lucky guy.

I was walking out of the grocery store today, beltless by accident, and both arms weighted down with bags. As the sliding doors parted, a burst of wind followed and I felt my shorts make a run for it, prison-break style.

When I felt the cold air hit my fun-sized buttcheeks, I panicked. I instantly stopped and threw my right leg outward to anchor the shorts in place.

There I stood. Legs akimbo. Arms filled with bags. Pants halfway off my ass. Utterly alone.

As I set the grocery bags down from one hand, I noticed a small crowd of people forming, waiting to enter the door that I was now blocking. I gripped my shorts and hoisted them back up into place as they began filing past me.

At that very moment, a boy scout stood up from his table directly outside, approached me and asked, "Would you like to buy some popcorn to support our troop?"

"Got my hands full here, buddy," I responded, "You sellin' any belts?"

"No, just popcorn" he said.

Touché, kid.

TOOTHLESS

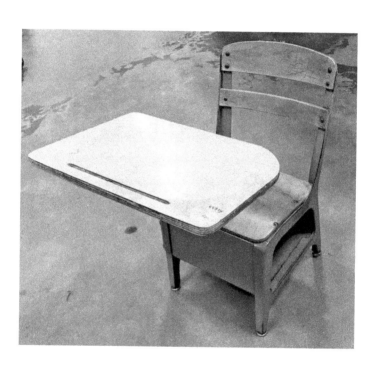

THE DESK

It was in the seventh grade that my education with the opposite sex embarked on its maiden voyage, and I had set sail for the island of Sheri Schaeffer.

This statuesque tween rocked the parochial school-mandated plaid skirt and white button-down like no other. Sheri had penny loafers with a shiny Abe Lincoln in each, cuffed white socks, and a big melodious laugh, which I was always working to coax from her.

But the key to my infatuation with Sheri was her gorgeous, thick, long, straight light-brown hair.

You see, I sat behind Sheri for the majority of that schoolyear, until Sister Virginia banished me to the back corner of the classroom for accusing her of

playing the wrong guitar chords to "Are you there, Lord?" For the record, they *were* the wrong chords, but I digress.

On a daily basis, Sheri's hair would wondrously dance for me. Just me. Back and forth, back and forth, oftentimes grazing the top of my wooden desk and occasionally sweeping my pencil loose from its notched bed so that I could catch it as it rolled down towards me. It was our secret little game that I'd one day be able to disclose to the future Mrs. Martinez.

The wooden desks of the 1980s catholic schools were as specific as the curriculum and just as unforgiving, with a hardwood desktop, the hardest of wood seats, an indestructible metal frame, and a built-in under-the-seat storage cubby for your books and supplies.

The construction of this desk would prove to be the iceberg to my Titanic.

It was a day like any other. Pledge of Allegiance, morning prayers, announcements, and straight into the day's lessons, which in this case was a

fifteen-minute writing assignment for each of us to complete individually at our desks. Sister Virginia's instructions were for total silence during this assignment, which we followed.

To this day, I have no idea if I finished my writing assignment early or if I even began it. My attention was consumed with the dance that was happening directly in front of me. I don't know what it was about Sheri's hair that day – maybe a new shampoo or a fresh brushing – but I was entranced. I ran my pencil side to side through the tips of her hair as it lay on my desk, and I knew. I knew that this was my moment to further our courtship. It was time for me to finally let Sheri know how I felt about her and my intentions for our future. It was time for me to become a man and confess.

The only question was how. Do I fold up and pass a note? Do I ask a friend to find out who she likes at recess? Do I push her?

Then it hit me: I'll just tickle her! The perfect plan unfolded as if IT were the subject of that day's

writing assignment. It was flawless. A tickle. What better way to invite Sheri into my secret and our future together? It would be the flirtatious move I needed to prove my intentions and profess my love.

I set my pencil down, readied my fingers in the dual pistols position, sat up straight to maximize my reach, and went for it. A two-handed jolt landed perfectly on both sides of her unprotected midsection.

No amount of planning could have prepared me for what came next. Before I could even retract my hands, Sheri's body rigidly and forcefully snapped upright, then she squeezed out a fart that shattered the silence of the room, as well as all my dreams.

The iceberg had struck.

Sheri's poor little butt-cheeks had surely been working overtime to keep this airy prisoner confined. The jolt of my fingers had shocked her body into a full spasm that forced her clenched muscles to release and relaxed muscles to contract. The desk's wooden seat acted as a megaphone, announcing a

blast that if recorded, would be the audible definition of the word FART! It truly was perfect. Clean push, great tone, woody reverb, upward inflection as if asking a question, and stuck the landing with a watertight pinch.

As if on cue, the entire classroom of synchronized heads darted back in our direction, looking to identify the cheese-cutter.

My mouth was open, eyes wide, hopes dashed, as my dual pistols began retracting in slow motioned disbelief.

As if she'd rehearsed it, Sheri immediately yelled to the class, "IT WAS PAUL!"

I sat back in my desk and embarrassedly took the hit. I didn't even fight the indictment as the kids' roaring laughter was quickly hushed by Sister Virginia. I considered it my act of contrition. My punishment for showing the love.

Sheri and I never dated.

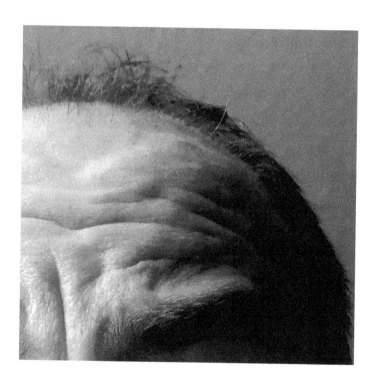

THE SILVER FINGER

In a place on my head that once boasted a great society of hair, there now lives only skin. Cold, barren, exposed to the elements, and the source of glare in countless photos, this follicular wasteland hasn't known life in many years.

…Until last night, when the mirror shined light on a single hair jetting forcefully through the crust of baldness, as if shouting "WAIT, IM HERE!" The only problem was, the rogue hair was stark white.

Like a gigantic bleached middle finger rising out from the waters of my gene pool (ala Robert DeNiro in Cape Fear). I was being flipped off, once again, by my pedigree.

I can only imagine the strength it took for my body to sprout this obscenity. Clearly so much that it didn't have enough left in the tank to color it!

To you, silver asshole finger, I say............ "uuuhh, rude."

TOOTHLESS

THE TOP GUN

Backstory: my wife and I own a wedding & event property in Sebastopol, California. The venue is on a septic system, which was an entirely new concept to me before this fateful day.

If you're unaware, as I was, septic systems are basically the opposite of a public sewage system. In most of our homes, when you flush a toilet, the madness in the bowl disappears from your life forever. Amen.

When you have a septic system, however, a flush sends the bowl-carnage to a "waiting room" in the form of a giant underground tank, where it hangs out with all the other unmentionables, sometimes for years. "Servicing" the tank is when a disposal company comes to empty the crap capsule by

vacuum sucking the contents into a tanker truck for transportation to the Great Beyond.

Today, we had the septic tank serviced for the first time since buying the property. Since at that point I didn't know what a servicing entailed, I arrived onsite early that morning to lend a hand. I shoveled away the topsoil that covered the tank opening, then stood back, about three feet from the lid, as the sewage technician started working.

Little did I know a two-year collection of keister-cakes from anxious brides, nervous grooms, and all their loved ones, had been patiently holding its breath, waiting for liberation.

When he popped the top off that turd-cannon, there was a blast of incarcerated butt-steak exhaust that when finally freed, took its revenge on every living creature in proximity.

The backdraft of this captive beast literally knocked me off my feet, and detached me from coherence, like the jet-wash that sent Maverick into a flat-spin and killed Goose.

I could feel myself teetering between this world and the ever after. Yet, somehow, I had managed to hold on to the shovel while this time capsule of hell's candy continued choking me out with its invisible grasp.

And the tech? He just stood there with a shocked look on his face as he watched me thrashing around in the dirt, hollering profanities, praying in tongues, and begging for the strength to shove my head up my own ass.

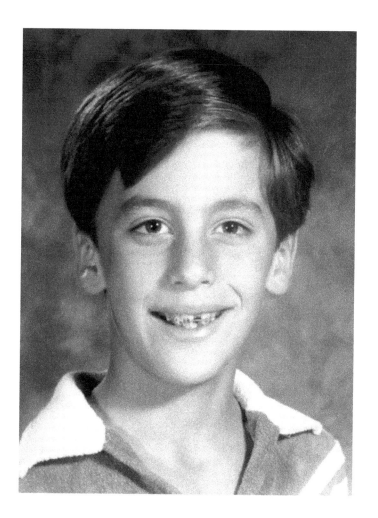

THE TOOTHLESS

If you're wondering how this book got its title, just take a look at this handsome devil. Notice anything missing?

A large portion of my youth was significantly shaped by the absence of my front tooth.

It's quite a look. Caught somewhere between the worlds of normal, and "What the *what*!?" Impossible to hide, and even more impossible to pronounce "F," "S," or "TH" sounds. It was fuckin' weird, and I knew it.

I specifically remember taking this picture thinking, "It's not REALLY that noticeable, right?" I considered a closed-lip smile, but the braces would have made it look like I just puked in my mouth.

My only bet was that the plunging v-neck of that plush velveteen number would be all the distraction a boy needed.

I was often asked by both kids and adults what had happened to my front tooth. "The dentist pulled it out by mistake" was my pad answer, and although that was the truth, it inevitably spawned additional questioning. I can assure you, however, I didn't have meth-mouth.

I was born with an extra tooth impacted above the roof of my mouth, as evidenced by x-rays taken when I was young child. When I was in the fourth grade, a surgery to remove that extra tooth concluded with the mistaken removal of my front permanent tooth. That big beautiful pearly white was just a little too close to the extra tooth, and the dentist grabbed the first one he found. The wrong one.

The second surgery was aborted, after digging through my hard palate, for fear of damaging my nasal passages. The third surgery was postponed

until after that little bastard actually grew through the roof of my mouth. Yes, I had a tooth sticking out of the roof of my mouth. My tongue didn't know what the fuck was going on.

The third surgery was more of an extraction, and although "successful," it was a very painful and traumatizing one, because I was awake through it all. Screaming and thrashing around in the chair, two nurses holding my head, while the surgeon pulled and pulled, mom crying in the waiting room because she could hear it all.

An uncontested malpractice suit put a few bucks in the bank with a court-ordered lock on the money until I turned eighteen.

The awkward toothless years produced some anecdotal moments. Kids were always on-point with a mean but creative diss. "Snaggletooth" or "snags" for short got some mileage. "What's up, Whistle Head?" was clever, though it took me a minute to understand, but in hindsight, "Donkey Chompers" took the blue ribbon.

Even as an adult, while watching the move Shrek, when Donkey appeared on screen, I found myself stink-eyeing the crowd to see if anyone was giggling at me.

For a couple years in junior high I had a retainer fitted with a fake tooth. This became a well-known parlor trick in my friend circle because I could suck the retainer out at will, thus causing the fake tooth to fly free from my grill, producing a giant hole where there was once a tooth. It freaked people out and we loved it. There were countless times on the school bus where I'd perch up to a window seat, make eye contact with a driver in the car next to us, give them a giant smile to which they'd always smile back, and then I'd aggressively suck the tooth from my face and go cross-eyed. If only the technology existed back then to record their reactions, surely I'd have been a YouTube sensation.

Eventually I had a dental bridge with a prosthetic tooth cemented in place, robbing me of my superpower.

My young adult years brought a few occasions when my bridge would get accidentally knocked out. One time, I was trying to learn how to surf while my girlfriend and her sisters watched from shore. The first wave I attempted to catch slammed the surfboard into my face, immediately knocking my bridge free. I could feel it bouncing around in my mouth for a split second, but the thrashing of the wave sent it shooting into the ocean. Gone forever. When I finally got my footing, I realized two things. First was the $3000 it was going to cost to replace my bridge, which I did not have. Second, and even more distressing, was that at some point I had to get out of the damn water!

I approached my girlfriend and her sisters with a gigantic hole in my face, equally shocking the shit out of all three. You never really forget "the look" on someone's face when they see you without that tooth.

On another occasion many years later, my buddies and I were celebrating a friend's bachelor party at a strip club in Las Vegas. One particularly

aggressive dancer had climbed onto my lap and was repeatedly inviting me to take her into the VIP lounge for a private dance. Each time I refused she would throttle up the dance moves on my lap, hoping that the skills demonstrated would change my mind. After the fourth rebuff, she busted into a full-body gyration, slamming her pelvis into my thighs and pumping her arms up and down like some kind of deranged choreographed seizure. In the process, however, her elbow smashed me in the mouth, knocking my bridge out. My toothless head snapped back from the blow, revealing the abyss between my teeth. She immediately jumped off my lap, gave me "the look," and ran off.

Several years prior to that, when I turned eighteen, the malpractice money I'd been awarded by the court was unlocked. I was rollin' in dolla dolla bills, y'aaaall!... for about nine months. The money dried up quickly in the hands of a kid with zero fiscal awareness. I mean, I was buyin' shit for strangers! One time my dorm buddies wanted to go target shooting and asked if I wanted to join

them. My response: "Hell yeah, lemme go buy a gun real quick!"

The money was enough however, to pay for my first year of college AND the down payment on a brand-new SUV. Thinking I was hot shit and hilarious, I bought a personalized license plate for my new ride that read "TOOTHLS" with a frame that mocked, "Dr. Tucker, thanks for the car."

Two years later that SUV was repossessed by the bank for non-payment. What has two thumbs and learned the meaning of "irony" that day? This dumb-ass.

I still live with a fake front tooth.

THE BUDDY

My brother's dog Buddy is a spazzy pooch, to say the least. He once, in a mindless dolt-bolt, ran full-speed into a fire hydrant, and though he fully recovered physically, he's still got that dingbat twinkle in his eyes. He's like a canine tweaker.

On this particular day, Buddy had ripped the cables from a huge metal box on the side of the house that controlled the exterior lights, so I went over to my brother's house to fix it.

In order to repair the cabling, I needed to unbolt the big-ass control box from the house and disconnect the wiring. As I knelt down in the grass, cradling the heavy box with both hands, I realized

that we needed a longer screwdriver and sent my brother to retrieve one.

The weight of the box quickly became too much for me, so I leaned forward to rest my elbows on the grass. As it turns out, I had unknowingly put my body into a position known as "presenting" in the animal kingdom, and it was at this very moment, that my life was thrown into slow motion.

Buddy's first paw landed squarely on my right shoulder and seemed to clench down and stabilize itself. Initially I didn't think anything of it, as he has a tendency to jump on people.

The second paw hit with intention, targeting my left shoulder with a quiet but stealthy force that said "Sssshhhhh… here we go."

As the gap between our bodies began to close, I could feel Buddy's arms bending as he reasserted his two-pawed bitch-grip. My useless arms offered no fight, immobilized as they were by the precious sixty-pound control box which was tethered to the house by wires. My body began to rhythmically

shake forward and back, although not at my command. The hump motor in Buddy's ass slammed into choke-start mode as his rapid, indiscriminate thrusting finally took form. Buddy was goin' to town on me.

I'll die long before I shake the image of my brother's face as he rounded the corner, screwdriver in hand, and saw Buddy straight-up dog-hammering me while I screamed, "STOP! NO!!! STOP! BUDDY, NO!! GET OFF ME!!"

Buddy locked eyes with my brother, briefly pausing the devastation, then quickly continued his onslaught. It was as if an audience had just appeared to see him headline. He had really locked into his rhythm now, and my shouted commands only seemed to add a soundtrack to the performance. (In my nightmares since, I can see the cunning grin on his face as his head jerks up at my brother as if to say, "WASSUP?!")

Since then I've had some time to contemplate what may have provoked this unrelenting bone-down,

and can only conclude that the smell of our own dog, Sissy, was all the bitch cologne he needed. Surely, I was soaked in it.

THE HYSTERECTOMY

The toothless saga of my youth created a bit of a phobia for me that directly related to dentists and hospitals. The smell of those places, which felt like a combination of rubbing alcohol and pain, were deeply planted into my young psyche.

When I was thirteen, my parents loaded us into the family van for a trip to visit my Aunt Dory, who had just undergone a hysterectomy. I had no idea what a hysterectomy was, only that it had to do with her "lady parts," which added to my discomfort.

As the automatic hospital doors flew open, I smelled that familiar smell and thought to myself, "Oh boy, this is NOT good." The further we got

into that hospital, the weaker my legs became and the more panicked I felt.

We made it to Aunt Dory's room and the five of us filed in around her bed. I skillfully grabbed the spot at the end, where there was a large wooden footboard I could anchor myself to. I clutched onto it for dear life and tried to convince myself that everything would be alright.

Small talk with my aunt began to lighten the air, and for a moment I felt like I could actually make it out of there unscathed. I started to believe I was going to be okay!

Right then, Aunt Dory slid the bed sheets down, and began pulling her hospital gown up to expose her abdomen, asking, "Hey, you wanna see my scar?"

<cue the sound of Paul's lifeless body hitting the hospital room floor>

When I regained consciousness, I felt my feet dangling off the ground, my dad's arm curled around

the front of my body, and water splashing into my face.

"Wake up, Paul," I heard someone say, "You're okay, Paul, wake up."

THE SNEEZE

Allergy season almost killed me today.

As I was standing in the quick-check line of our local grocery store, I felt an unrelenting tickle in my nose, which clearly indicated that I was about to be overtaken by a series of sneezes.

The first three were silently diffused into the shirt-sleeve of my bent right arm. But the fourth? The fourth sneeze was so sudden and so impossible to stifle that when it snuck up, I barked out a violent and thunderous "CHEWWW!!!"

So ferocious was that sneeze, in fact, that the elderly woman behind me, holding only a handful of daisies for purchase, simultaneously yelped and blasted out a round from her toot shoot!

I had literally sneezed a fart out of the poor woman behind me.

After my deepest apologies and an offer to pay for her flowers, I ran out to my truck and laugh-cried myself to the brink of unconsciousness.

I'm so impossibly sorry, Old Daisy Fart Lady.

TOOTHLESS

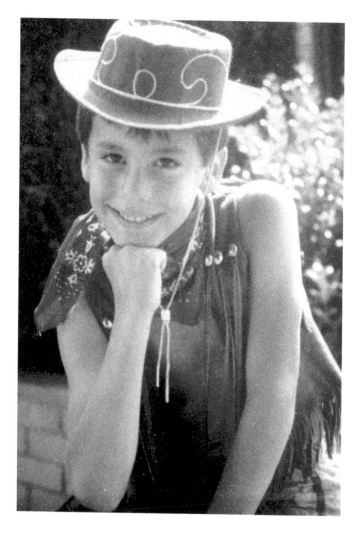

THE COWBOY

A man, a pony, and a wagon full of costumes. Definitely a sight that makes you pause, right? I could see them walking down our cul-de-sac, the man knocking door-to- door with a giant camera around his neck.

Before he even reached our porch, my mom swung the door open and asked, "How much?" Within seconds she was yanking the t-shirt off my body and I remember thinking "Wait... what the *hell* is going on?!"

The leather vest appeared, to which Mom shouted, "Perfect!" The matching leather chaps over my soccer shorts were conveniently left out of this shot, probably for fear that it might foil the illusion that I was indeed a cowboy. A hat, which was clearly

rescued from the local Little Miss Sunshine competition, and a bandana-kerchief completed the look.

Pony Man lifted me onto the horse, which you may notice, is completely absent from the shot. Seriously, where the fuck is the pony?! Wasn't that the whole point!? I swear to you, I did not crop this photo. (I coulda been sitting on the station wagon!)

A brush of the bangs to complete the bowl, a clenched fist under the chin, a pre-toothless smile, a sweet flex of the buttered abs, and click. Life is changed forever.

It was years before the neighbors stopped calling me Paula, finally realizing that I was a dude. I someday plan to recreate this legendary shot. It's gonna have to be one hell of a horse, though.

THE FLY

I'd like to report a crime, although I suppose I'd also need to confess to that same crime. In this story, there is a victim. There is a culprit. And they are one and the same. Me.

I was standing in my kitchen earlier today when I observed a fat, sluggish, boisterous housefly struggling to hover in front of me. Although the fly was moving really slowly and seemed to be working exceptionally hard to maintain elevation, I felt the need to act quickly.

"No sense in wasting time retrieving the flyswatter under the sink," I thought to myself. Instead, I slowly raised and cocked my right arm, widening my palm in preparation to deliver a stealthy, swift, open-handed slap of death.

The fly buzzed carelessly before me.

As if fired from a cannon, my giant hand rocketed itself downward towards the fly, powerfully cutting thought the thin air on its way to certain destruction.

Much to my surprise, however, I watched helplessly as my hand missed the fly entirely, speeding past the chunky insect and continuing on, in search of another target.

In that moment, I had lost complete control of my own hand.

Like a blind bolting horse, it continued until impact, pulverizing both of my unsuspecting nuts.

A pained and betrayed shriek accompanied me to the ground, where I curled in the fetal position, wondering what the fuck had just happened. (It should be said that even the slightest grazing of a man's meat-and-two-veg is enough to bring him to his knees, not to mention an unobstructed, high-velocity, ill-intentioned, full-strength thumping.)

Until that moment, I thought surely there was some sort of innate, self-preservation mechanism that would NEVER allow for such an offense! I mean, if you hold your breath for too long your body takes over and says "Okay, this dipshit decided to stop breathing again so I'm gonna knock him out and start breathing for him on my own," right!? When your enormous open hand is catapulting itself towards its own defenseless ballbag, isn't there some sort of internal abort button that thwarts the act!? Well, I'm here to tell you: there isn't.

Instead, I found myself lying on the kitchen floor, holding my ween and hearing nothing but my own agonized groans and the gentle buzzing of the chunky fly above.

THE FELICIANO

As part of my career in corporate events, I've spent many years handling politicians, comedians, musicians, and celebrities of all types.

My very first assignment in this arena was a private dinner and concert starring José Feliciano, the Puerto Rican musician, singer and composer best known for his rendition of The Doors' "Light My Fire" and the bestselling Christmas single, "Feliz Navidad."

My job was to greet Mr. Feliciano, his band and management team and escort them to their green room. There, I would provide the requested refreshment and dining selections, then bring Mr. Feliciano to stage at the appropriate time. After the concert I would shepherd them back to the green

room, and finally assist them to their vehicles for departure. Sounds easy enough, right?

Though I was nervous being near this musical icon, Mr. Feliciano's kindness and the generosity of his touring management put me right at ease. After hearing my last name (Martinez), he immediately inquired if I spoke Spanish, to which I sheepishly answered, "No." They all laughed and we moved on. I walked them to the green-room and left them to their pre-show rituals.

When the time came for Mr. Feliciano's performance, I was instructed to go to the green room and politely inform the group that we were ready for them on stage.

I walked the long corridor to the green room, rehearsing in my mind exactly what I would say when I entered. I didn't want to sound like I was ordering Mr. Feliciano to do something, but my clients' anxiety was ratcheting up with each passing minute and they needed him on stage as soon as possible.

I opened the door to the green room, which captured the attention of everyone inside, and in a clear but inviting tone announced, "MR. IGLESIAS, WE ARE READY FOR YOU ON STAGE!"

The room flatlined. Mouths stopped chewing. Expressions dissolved. Drink glasses halted, as if suspended in mid-air. The food stopped steaming. Conversation stroked out. Every face in the room had a blank but crazed look on it, and they were all focused on me. It was as if I had walked into the room, dropped my pants, and farted in the menudo bowl.

The smile began to fall from my face as I looked to the tour manager, who simply pointed to the man standing next to him and said, "*This* is Mr. Feliciano."

The life emptied from my body. I went limp. My mouth slowly fell open, preparing for the inevitable dry heaves. In the most contrite and shamed voice, I stammered and fumbled my way to some sort of an apology.

"Mr. Feliciano, I am SO, SO profoundly sorry," I whimpered, to which he immediately responded, "That's okay, Rodriguez, let's go play!"

THE CART

Today I was walking out of Target with a cart-ful of household supplies.

On my way out the double doors, I used my innate powers of transformation to instantly convert myself into the shape of a moron.

As I strolled down the ramp to the parking lot, without a shred of common sense or restraint, the moron in me decided to jump on the back of my cart and take it for a ride to my car.

I should point out here that I am thirty-three years old.

The only problem, other than being a fucking adult, was that I was easily one hundred and sixty pounds heavier than the last time I tried this fun

little stunt. This gross miscalculation had a very specific and immediate reaction.

The instant my second foot came off the ground to hop on the lower rack of the cart, my entire body violently catapulted backwards.

Have you ever seen a dog run full speed at something without realizing it's on a leash? It was as though my body was leashed to the parking lot blacktop, and I had run out of slack.

For the briefest of moments, I was staring directly at the sky, still clutching the handle of the cart, which was now airborne. The blue sky went black when my back made crushing contact with the asphalt, causing my legs to extend and lock, launching the cart even higher into the sky.

Fueled by my bucking legs, the red, four-wheeled projectile took flight, expelling from it everything within. It then hung suspended midair for what felt like a solid forty-five minutes before finally returning to earth, hitting the ground like an exploding piñata.

The shit in my cart flew EVERYWHERE! Shaving cream, protein bars, toilet paper, deodorant, even the value-sized bottle of Rogaine, to add to the embarrassment, came un-bagged and went shooting in every direction.

My body's impact on the hot summer asphalt quickly slapped the moron out of me, leaving the regular me in hopeful denial, repeating over and over again, "There's no way that just happened, there's no way that just happened, there's NO WAY that just happened!"

But it had.

Every car in the parking lot stopped moving; every human being was frozen in disbelief, including the nearby Target employee who had been dutifully retrieving carts to return to the store.

I was hurt, but not injured. I flew to my feet and frantically collected my scattered purchases, throwing them back into my mangled cart.

After hastily restuffing the piñata, I was standing face-to- face with the Target cart kid, who was too

stunned to offer assistance. He just stared at me with his mouth open. My decimated ego, starving for a shred of redemption, crowed, "I bet you see that all the time, right?"

"Never once," was all he said.

This remains the most embarrassing public humiliation of my life.

TOOTHLESS

THE BUCKETS

Long before the age of technology, summertime with two working parents was both an exercise in boredom, and on occasion, the opportunity for an older brother to really see how high his asshole flag could fly. On this particular day, my flag pierced the stratosphere.

My younger brother Jason and I crafted a plan to create the ultimate water balloon fight. We pooled our spare change, jumped on our beach cruisers, and rolled to the nearest convenience store to buy two bags of water balloons.

We returned home with the ammunition, quickly changed into our bathing suits, and began mapping out the backyard battlefield.

My "base" was the water spigot near the back patio, and Jason's was all the way around the other side of the yard, at the garage door water faucet. Neither base could be seen from the other.

We filled each of the balloons, one by one, being certain to keep the growing arsenals evenly split. Every balloon was cared for like an unhatched egg, cradled with two hands, and gently placed into our respective buckets.

Buckets were taken to base, brothers become enemies, and the battle began.

Unfortunately, the inevitable happened pretty quickly. We both ran out of balloons. What we still had, however, was a strong case of the fuck-arounds. With that, we decided just to fill our buckets and run around attacking each other with waves of cold tap water.

What you must understand is with this new water bucket war, time is a critical factor. It's crucial that you continuously weigh the value of being first on the battlefield, giving you the element of surprise,

with that of taking the time to fill your bucket with more water for a larger payload on impact.

A few bucket battles came and went without note. It was on the fourth or fifth, however, that would earn an entry into the history book of our lives.

As I ran back to base to refill my bucket, I felt the building pressure of a bladder that demanded relief. I was at a crossroads. Do I call timeout? Do I rush inside to pee, missing out on the valuable time needed to reload? Or, maybe, just maybe I could drop my little ding-a-ling into the bucket and let it roll.

That's exactly what I did.

I remember shutting the water off early because the bubble formations were getting a bit too diluted. I wanted a concentrated yield. This *had* to be the kill shot.

I walked slowly, confidently, back onto the battle-field. Like a jet fighter pilot about to release hell

fury, I could hear the cockpit conversation with HQ in my head. My brother rounded the corner, still filled with playful enthusiasm and a giant smile on his face as he splashed his bucket onto my unflinching body. I pulled my arms back, tilting the bucket slightly forward, and I heard it: "Fox 3, Fox 3, safeties are off, I've got good tone… FIRING!"

Jason stood motionless, his innocence still momentarily intact, as my homemade yellow napalm catapulted towards him.

It hit with precision. It hit with force. I lit him up with a wave of yellow devil juice that splashed up the front of his body, all the way to his chin, and off both shoulders.

The joyful expression on his face began to shift into one of total recoil and curiosity, as if to say, "What the FUCK IS THIS!?" Clearly, he detected about a 78.6-degree temperature change in the liquid that showered him. The steam began to swirl and plume off his body while his nose searched for

the answers to his face's question. Then the answer came.

His expression can only be described as that of someone who discovers that their own family member has betrayed them to the feds.

Jason's emotional plate was bursting, overflowing with total disbelief, shock, betrayal, and a side of hot urine.

He stood there producing steam for another fraction of a second before collapsing to the ground and feverishly thrashing his body round and round, back and forth, while soul-screaming at the top of his lungs.

The freshly-cut lawn created a sort of grassy batter that caked itself onto his pee-soaked skin, like a human corndog.

His screaming was primal. Like something you hear in old footage of a live Beatles concert.

I left the scene before the grass-dipped piss-churro that was my brother made it back to his feet.

Eventually, the other inevitability would happen. Dad would come home. I knew as soon as he walked in the front door Jason would immediately share the news of the day. Hoping to escape the wrath, when I heard Dad's truck pull into the driveway I quickly got naked and jumped in the shower. Unfortunately, that wasn't quite the deterrent I had hoped for. Turns out, asshole flag-flying comes with its own set of specific consequences, wet or dry.

THE LADIES MAN

"**N**o steady girlfriends/boyfriends before you're eighteen years old" was a rule my dad set into place, repeated often, and heavily enforced around our house while we were growing up. Case in point: when my sister was in the eighth grade she was given a gold necklace and giant chocolate Hershey's kiss from a boy who crushed on her. Suffice it to say all hell broke loose in our house that night. There was a lot of yelling, some tears, and several meetings that followed, including one with the boy's parents. In the end, my sister returned the necklace but kept the Hershey's.

My seventh-grade year felt very much like the six that preceded it: parochial school, rules, uniforms, the same kids, and innocence. We played kickball

and butts-up, had milk service with lunch, said lots of prayers, and ran around the schoolyard in packs. But that was all about to change with a dose of elementary school romance.

Word on the blacktop was that an eighth grader named Gina Purdee had developed a crush on me. An eighth grader! It was unheard of at that time to crush on someone outside your own grade. It just didn't happen. So when Gina made her feelings known, it sent a jolt through the foundation of our tiny world, mine especially.

Gina was a popular girl – super-athletic and star of the school softball team. She had short blond hair, parted down the middle and feathered perfectly, like gorgeous blond curtains. She walked with the kind of confidence that scares the hell out of seventh grade boys.

The summer prior had been kind to Gina as her adolescence took hold, creating curves in new places that made her feel *even more* out of my league. Contrastingly, I was a scrawny underclassman whose

tighty-whities remained curve-less, as if worn by a 1970' store window mannequin.

And still, somehow, Gina liked me!

The news was delivered in the way all gossip was delivered in those days; on the bleachers at recess. Gina's group of scouts giggled the rumor to me and my friends, and asked if I liked her back? I was really put on the spot. I was nervous, embarrassed, and scared, but what could I do?! They were waiting for an answer! "Yeah," I squeaked in my ultra-pre-pubescent voice. The girls shrieked and ran off to deliver the spicy news, while my dudes looked at me like I was ALL that!

Details were exchanged and a rendezvous was set. Nutrition break, tomorrow, outside the girls' bathroom, come alone.

I made certain the next morning that my white button-up shirt was tucked into my corduroy pants nice and tight, my hair just right, and my toothless braces shining bright. It was game time, but it HAD to remain on the downlow. "No steady

girlfriend before you're eighteen years old!" was circling in my mind.

First and second period flew by, the nutrition bell rang, and it was GO-time. While the other kids were wildly running out to the field, Gina and I walked towards one another, approaching the bathroom meet spot. We finally stood face to face and, naturally, I was the one looking up. It was a moment I'd describe as the exact opposite of every romance novel ever written, but it was mine.

"Hi" Gina said.

"Hi," I responded.

"So, do you wanna *GO*?" she asked.

"Yeah," I responded, terrified and excited.

Then we both ran off.

"No steady girlfriend before you're 18 years old, old, old, old" still echoing in my mind.

But, the deed was done. I had a girlfriend. I was a man in love! I felt like running through the hallways singing, "Maria!"

The next day at the bleachers, Gina and I sat next to one another, sharing the occasional knowing glances that conveyed every detail of our secret. We were *going*! Gina asked if I wanted to walk up the street to Del Taco the next day for lunch, when school let out early. I agreed, though I knew it would be risky. It's a VERY busy public street between our school and Del Taco, in what still felt like a very small town, but I was locked in. My lady was counting on it.

The next day when school let out, Gina and I headed to Del Taco. I was quietly freaking out, eyeballing every car that passed in both directions, afraid that it might be someone who knew my parents and would someday tell my dad what they witnessed.

"No steady girlfriend before you're eighteen years old" was looping like a broken record. I have no idea what Gina and I talked about; I could only hear my dad.

It was on the *return* from Del Taco however, that changed the game.

Feverishly scanning the traffic, my only prayer was to make it back to campus without being detected. I never could have guessed that while waiting at the stoplight crosswalk, Gina would reach over and grab my hand.

"OH HELL NO SHE DIDN'T!" I thought to myself. But she had. The light turned green and we were walking, HOLDING HANDS! IN PUBLIC!

My limp fish grip went along for the ride as Gina squeezed tighter to publicly affirm our union.

I was tripping out, but silently. This was my *life* she's playing with here! Any one of these cars passing us could be someone who knows me. SHE'S HOLDING MY DAMN HAND!! So many thoughts were rushing through my mind: "Does she know people can SEE us!? Why did we have to get serious at such a young age?! I'm not ready for this! It's too fast! I gotta get out of this thing! What the hell is she thinking!?"

I weighed my options carefully. The thought never escaped me that literally at any moment, if

the mood struck her, or on a whim, Gina could handily beat the crap out of me without breaking a sweat, as could every one of her friends. But Dad's wrath was not to be trifled with.

The next morning, I sent my scouts with word. "It's over."

At lunchtime, I could hear Gina crying inside the same bathroom where our love affair had begun a mere forty-eight hours earlier. For a brief time, I was the Romeo to her Juliette. The Tony to her Maria. Two thousand, eight hundred eighty minutes of forbidden young love, with an all too familiar, tragic ending. The hand-hold had broken me.

Her friends would occasionally pop their heads out the bathroom door to give me a look that said, "As soon as Gina's done crying, one of us is gonna come fuck you up." Thankfully, that never happened. The gamble paid off. I never got tuned up by an eighth-grade girl, and Dad never found out.

THE FEO

My dad worked construction throughout my youth. As a parent of five, he needed to pick up all the weekend freelance work he could find, and he always needed a partner.

Dad's go-to partner for every weekend job was a tiny Mexican guy who couldn't have been more than five feet tall and maybe one hundred and twenty pounds fully clothed with boots on. He didn't speak a word of English, and he always had a cigarette in his mouth. He was the hardest working laborer I'd ever seen, and he was my father's golden boy.

Dad introduced him to me as Feo, and by the time I was old enough to accompany them on jobs, Feo and I were on a first name basis. That said, Feo

never actually spoke to me. Ever. I always figured it was because of the language barrier.

Between the ages of ten and thirteen, during summer break, I joined Dad and Feo on dozens of jobs. My main responsibilities were digging holes, sweeping, filling holes, and sleeping in the truck.

Although Feo never said a word to me, he did manage to give me dirty looks anytime I spoke to him.

"Buenos dias, Feo!"
Shitty look and a grunt.

"Hey Feo, ¿donde está el shovel?"
Shitty look and a point.

"Hey Feo, ¿donde está mi padre?"
Shitty look and a shrug.

"¿Cómo estás, Feo?"
Shitty look and nothing.

It was somewhat troubling to constantly be the recipient of such harsh scowls from Feo; after all,

I was just a kid. This continued for years, and I started to internalize it a bit, thinking maybe there was something he hated about me. Eventually, I figured he was a naturally angry guy, or maybe he was just a tiny chain-smoking asshole.

Many years later, I learned that in Spanish, *feo* means "ugly."

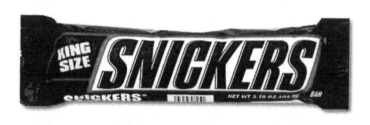

THE KING SIZE

I worked in a grocery store during my later high school years. Weekend shifts were my favorite, especially Sundays, which were predictably quiet and slow until about the time church let out. On this particular day, however, something happened that was altogether unholy.

Whenever I worked the early morning shift the first hour was spent walking around the store making sure everything looked clean and orderly.

After clocking in, I was making my way down one of the aisles when I was startled by a shadowy figure running across the rear walkway. I hurried down the aisle to see if there was a problem, but they were gone. Vanished.

I shrugged it off and continued to the loading dock to get my cart full of "go backs," in grocery lingo. As I returned through the store, I noticed a small spill on the floor, which sucked because that meant I had to get a mop and clean it. I bent down to inspect the spill but couldn't figure out what it was or where it could have come from. It looked like hot chocolate.

It finally occurred to me that the spill was in the exact same spot that I'd seen the shadowy figure, and suspected they were somehow connected. I looked down the length of the store and saw that the spill continued, like little hot chocolate islands dotting the floor. "WHAT THE FUCK!!?" I thought to myself. "YOU SPILLED YOUR DAMN DRINK ALL THE WAY ACROSS THE BACK OF THE ENTIRE STORE!?"

I bent down and inspected each spill. "CSI Orange County" had begun, and I was the chief forensics dude. I walked the subjects' splatter trajectory and began to notice formations on the islands. Cause for concern. I followed the spills through the doors

that lead to the restrooms. They directed me up the stairs, around the corner, and into the actual restroom, where the figure had somehow managed to spill hot chocolate on the wall of the bathroom stall. The toilet, however, was spotless and the shadow, once again, was nowhere in sight.

Right then, the smell of the room punched me in the gag bone. It was in fact my body that learned the truth before my mind. This is common in seasoned crime scene investigators. I wanted answers. I wanted to truth. But I couldn't handle the truth.

I had been tracking, tracing, and examining, a repugnant path of dooky-islands!! That's right. The chunky hot chocolate droppings were real-life human shit-ponds!

My body's innate fight-or-flight response sent my mind a crystal-clear signal to fly the fuck out of there!

I tiptoed past the turd trails and ran to find my manager, Kent. Struggling to catch my breath, I franticly tried to explain the discovery.

Kent inspected, concurred, and quickly closed the store.

Minutes later, over the store PA system, Kent requested that I come to the manager's desk. I reported immediately. In a serious and direct tone, Kent said, "Okay, Paul, I want you to get a mop and start cleaning from the dairy department down to the meat department."

I stood bewildered, debating my future. Although I loved that job, I knew I wouldn't be able to emotionally recover from cleaning up after the phantom shit bomber.

I untied my apron and began my farewell speech. Kent started cracking up. That ass-wipe just wanted to see the look on my face. He finally told me he was joking and that a professional cleaning outfit was on their way to "handle the problem."

Relieved and employed, I returned to my go-backs cart and immediately noticed sweet revenge hovering at the top of the heap. It was a box of Snickers

bars, king size. It was payback time, and I knew exactly what I needed to do.

I unwrapped one of the kings and warmed it in my grip. Then I began squeezing and twisting it in my hands, thoroughly wiping chocolate, caramel, nougat, and peanut chunks all over my hands, face, and lips. I'm not gonna lie, even though I was using it as a turd prop, I took a few bites.

I walked up to Kent, smeared in chocolaty vengeance. I told him that I had cleaned everything and that there was no need for the disinfection crew, casually chewing off a Snickers chunk from my knuckle. For a couple glorious moments, I could see Kent struggling to comprehend what the sweet fuck he was seeing. I scared him real, *real* good. "Snickers Satisfies," indeed.

THE NOTE

In the seventh grade, I spent as much time as possible at my best friend Peter's house. Mostly because there was zero supervision and his mom never wore a bra.

One day while hanging out at Pete's next-door neighbors' house, we discovered a vial of some super crazy-looking liquid in the older brothers' desk. It was silver and thick and it glided back and forth inside the tube in a way I'd never seen before.

Naturally, the next move was to dump some out and fuck around with it. Before long, we were pouring nickel-sized pools of it into the palm of our hands and poking at it to watch it break up into beads and then reform itself back into one glob. Fascinating stuff.

Though we were certainly able to read by that age, neither of us bothered to take a look at the label on the side of the tube, which clearly read "Mercury." We only noticed the label after about forty minutes of smashing that poisonous shit into our hands and fingers.

Having no idea what mercury was, when we got back to Pete's house, we innocently inquired about the stuff.

Peter: "Hey Mom, what's mercury?"
Mom: "A planet."
Peter: "No, like the liquid mercury."
Mom: "Oh, it's the silver stuff you see in thermometers."
Peter: "Is it bad for you?"
Mom: "You mean if you touch it or something?"
Peter: "Yeah."

I'll never forget Pete's Mom response as she walked out of the kitchen, a freshly-lit Benson & Hedges dangling from her lip and loose cannons jumping around in her tank top: "Oh, it's deadly. DEADLY!"

Pete and I just stared at each other as she exited the room, then, immediately started crying. We weren't sure exactly how or when the end was coming, but it was coming.

We ran to Peter's room, sat down at his desk, and tearfully wrote goodbye notes to our families. My terrified hand, still slick with metallic toxic residue, began my note with, "Please don't be mad."

When our notes were completed, we sat quietly on the bed in Peter's room, waiting to die.

THE EGG

I woke up early this morning and decided to head downstairs to eat on my own. My brother and two cousins were sleeping in on the first morning of our vacation, visiting and staying in a convent in Northern California with my aunt, who is a Catholic nun.

PJs off, clothing on, and I quietly headed down to the dining hall. PLENTY of early risers in this convent, and it didn't seem like they had overnight guests very often.

The immediate looks I received seemed puzzled, as if they were thinking, "Why the fuck are there kids in here?" but they quickly reminded themselves that they're nuns, changed their facial expressions, and greeted me with warm morning smiles.

Unlike at home, the gigantic kitchen offered a bounty of available food options. Last Supper, my ass, this place had it all, and breakfast was on MY terms today. I loaded up a big plate of the basics, grabbing some fruit on-the-side to appease any disapproving observers, even though there wasn't a single "mother" – other than by name only – in the building to fear.

Last stop was the microwave to heat up some bacon that had gone cold. I took my place in the microwave line behind two nuns, both wearing their traditional habits. Politely, I kept my eyes to the floor, trying not to stare at the nun directly in front of me who appeared to be just shy of her one hundred forty-third birthday. Honestly, I had never seen someone that old before and yet, here she was, standing in line just like me.

She turned around, smiled at me, and said, "Good morning, dear."

"Good morning," I replied, then added silently, "Please don't die right now."

You see, I was an al[...]
home, and I'd seen [...]
funeral services. This
like, only not standi[ng...]
morning." Was she [...]
like the best nun he[...]
her and stuff? Was h[...]
at this point? Wasn't [...]

on. "She's ok[...]
hundreds [...]
We w[...]
An[...]

be making this food for her? How did she get dressed? SO many questions raced through my mind, but I remained quiet and respectful, eyes to the floor.

Eventually, it was her turn. She scooched her way forward, opened the microwave door, and put inside a tiny bowl holding a single hard-boiled-egg. "What the hell is she doing?" I marveled, "I've never seen that done at home before. Is she allowed to do that? Can we get a judge or a Mother in here to weigh-in on this one?" My mind was racing, but my eyes were down.

I heard the door close, and the beeps of a few pressed buttons before the microwave powered

viously done this before, probably
ıt times," I assured myself.

ıted. And waited. And waited some more.
ıd then, out of nowhere, in the murmured morn-
ıng silence of the convent dining hall, BOOM!!!! A
massive explosion inside the microwave breeched
the serenity of the room, scaring the *holiest* shit out
of me and every nun in there!

I looked at the old nun, surprised she was still
alive, but incredibly, she didn't seem alarmed by
the blast. Instead, she turned to me and asked,
"Can you please help me, young man?"

Was I even allowed to say no? I wondered, then
walked obediently forward until I was face to
face with the microwave door. Then, she pulled
it open.

It's very rare, in the actual moment, to know
whether a life experience will just sail through the
rivers of your mind into the great beyond, or one
that runs aground, implanting itself into the bed-
rock of your psyche for eternity.

The widening microwave door discharged an insidious gust of artificially heated chicken-ass directly into my face. We had hit bedrock.

The expulsion enveloped me. It circled my body and took hold. It destroyed my will. It took things from me, the way hope is taken from prisoners in solitary confinement. IT had momentarily imprisoned me, invisibly choking me out like a gaseous chicken poltergeist.

The inside of the microwave was annihilated. Egg shrapnel dripping from the corners. The poultry version of a Jackson Pollock.

"Can you please help me, young man?" I heard again in my ringing ears.

What in the sweet unholy hell could I do!? Solomon himself would need to use a lifeline on this one!

I just stood there.

Frozen in time…

This story you just read happened when I was twelve years old. I have absolutely *zero* memory of

what happened next. I swear to you, dear reader, this is not for dramatic effect or hyperbole. It's the stack-of-bibles truth. I have NO idea what happened after she opened that microwave door in my face.

To this day, I have an irrational fear of hard-boiled eggs. I can't be around them without being incredibly uncomfortable. I can't watch one being eaten, let alone talk to someone while they do. It has been the focus of many pranks and gags from friends, and I think I'll die afraid of hard-boiled eggs.

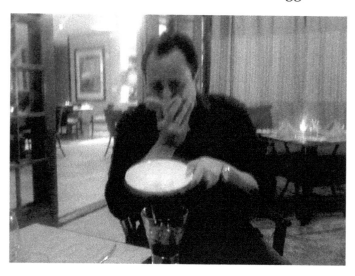

Case in point, this photo. That bowl was *supposed* to be a bowl of delicious vanilla ice-cream. Instead, my "friends" had the restaurant swap out the two scoops with hard-boiled eggs, which I noticed only after putting a spoon into one of them.

Oh, that nun. I bet she's still there.

THE NAKED WOMAN

My very first job was a paper route. The early 1980s version, throwing newspapers from my bicycle, seven days a week, with early-morning deliveries on Saturdays and Sundays.

Decent job, cash business, hard work, but when the district manager drove up to the "drop house" with a trunk full of bonus prizes, one of which was an enormous bucket of red licorice, I was committed. My only goal in life at that time was to earn the title "Paperboy of the Month" and take home that gorgeous tub of what seemed to be two lifetimes worth of red vines.

The "drop house" was a centrally located home where the papers were delivered in giant separated bundles. There, multiple paperboys would

come to assemble the day's distribution before heading out on their routes. Thankfully, mine was only five blocks from home.

The weekends were rough. A five-a.m. wakeup was required so your route could be completed by seven at the latest. It wasn't fun, but a ride to the donut shop for a bag of the hot-n-fresh ones after work made it all okay.

This particular Saturday, however, I wouldn't have traded for all the donuts in the shop.

I'd woken up a bit late, so by the time I reached the drop house, the other boys had been and gone. I quickly rubber-banded my papers and was starting to load them into my canvas delivery sack when I noticed the sound of a voice behind me.

It was garbled and slurred, but definitely sounded like a woman's voice, which seemed unlikely considering it was just after six a.m. It wasn't until I heard two words spoken clearly through the muddle of gibberish that I turned around. Those words: "fuckin' asshole."

When I turned back towards the house directly next door, on the concrete driveway, lay a woman in her forties, fifties, or sixties (what the hell did I know, I was thirteen years old!), rocking back and forth, angrily talking to herself, completely naked.

A monumental moment was taking place because this was the first naked woman I had ever seen in real life. A living, breathing, slurring, cursing lady, without a stitch of clothing on her body. I'd been raised in a zero-tolerance household when it came to nudity and had reached an age where I was desperately hurting to see some skin.

My initial reaction was shock. I stood there like an open-mouthed statue, still wondering if this was real, who may have been watching, and how I might get in trouble for this. To my added surprise, the lady then decided to just lie down and have a rest.

I slowly began walking towards her, every step bringing her nudity more sharply into focus. My stunned arousal, however, was met with a healthy

dose of "hmmm… really…?" I knew of course that I was looking at a naked woman, but I didn't really expect it to look exactly like that. From a purely descriptive standpoint (no body-shaming or exaggeration) I would say she was a woman of healthy proportions. Thick dark tattered hair, smeared makeup, pale white skin, thick ruddy legs, a sizable, unruly bush, and a body that seemed to comfortably melt right into the contours of the driveway.

It was her nipples, however, that demanded my attention. Her breasts appeared to have lived some life. Battle-tested. Long, large, heavy, full-bodied boobs with nips whose size and color resembled small, burnt tater-tots.

Regardless, I was entranced. Inching closer to her, I hadn't blinked in several minutes. Finally, I stood directly over her, trying my best to record every moment in my mind. I was afraid that she'd wake up and start screaming at me, but I was willing to roll the dice.

I gazed at this drunken work of art, examining every inch, every roll, every hair, every jiggle. The

thick, dark lady-garden bursting from between her legs was the most beautiful thing I'd ever seen. She is likely the reason I'm a fan of the retro '80s bush today.

A brief moment of chivalry washed over me as I took off my jacket to cover her up. I have to admit, I hesitated before actually extending my jacket towards her. I needed more time.

Right then, the neighbor from across the street came running over. Mrs. Cockblocker. She barked at me to "let her be" and "get away from her" as she ran towards us, carrying a rug from her house.

She laid the rug over the naked woman, urging her to wake up and go inside. Like the door that slams shut when your times up at a peep show, Mrs. Cockblocker's rug stymied the spectacle.

I don't remember if I delivered papers that Saturday. I had other things on my mind. One thing was certain however; I was the last kid to finish folding his papers from that day forward.

THE NUT

When I was a kid, maybe around seven years old, my siblings and I were jumping on the couch. For reasons still unknown to anyone, I was holding a small metal hex-nut inside my mouth for safe keeping, which I then proceeded to accidentally swallow. I wasn't a smart child.

After confessing the blunder to my mom, an immediate trip to the doctors' office followed. An x-ray showed the tiny piece of hardware temporarily vacationing in my stomach before it was to make the dreaded and inevitable journey through the dirty place.

Dr. Kravitz told Mom that we had to make certain I actually *passed* the nut, the concern being that it might get stuck somewhere along the way.

Mom must have been able to read between the clinical lines because I don't remember Dr. Kravitz detailing the work that awaited her, but somehow, she knew. She knew the way only an unconditionally loving mother could.

While driving home, Mom repeatedly instructed: "Paul, you have to TELL ME when you need to go poop. Don't do it without me."

I was suspicious, but obedient.

Eventually, the time came. On my way to the restroom, I yelled out, "Hey, Mom, I have to go poop now!" to which she shouted, "WAIT FOR ME!"

"Wait for me?" I contemplated. What the hell was Mom talking about?

I closed the bathroom door to do my business when it immediately came flying back open! Mom was standing in the doorway with a paper plate and a plastic knife. Even at seven years old, I remember thinking, "Wait, what the fuck is happening here!?"

Mom pushed her way into the room and ordered me to pull my pants down and squat over the toilet without sitting down. I did. She then instructed me to point my little thing towards the toilet water but again, not to sit down. Blindly, I obeyed and positioned myself as if I were sitting in an invisible chair. Pants at the floor, squatting over the bowl, with one hand holding my shirt up and the other directing my junk. She then reached behind me with the paper plate, tucked it right underneath my tiny butt-cheeks, and said "Okay, go."

GO!? Could it be true? Did Mom really want me to shit on this plate!? I was disoriented and consumed with stage fright. When did I become the "shit on demand" kid in the family? Everything in my mind told me not to do this, but Mom kept ordering me to "GO!"

I was so confused, but I was also crowning. The pressure mounted. My bent legs shivered more violently with each passing second. I turned my head away to maybe somehow evade the shame

in both our eyes, and I respectfully pushed out a healthy butt-steak onto Mom's paper plate.

She pulled the steaming specimen out from underneath me, and I momentarily marveled at the sight. I'd never seen a turd outside its normal habitat, let alone on a plate. I remember being amazed at how much the toilet water swallows up the stank of a sweltering log.

Mom started cutting into my plated specimen with the plastic knife, mining for the metallic obscenity and fighting her own gag reflex.

No luck.

Shits two and three also offered no reward. But blessed number four brought the goods! I could be wrong for it, but I felt proud. Mom never really looked at me the same way after that.

TOOTHLESS

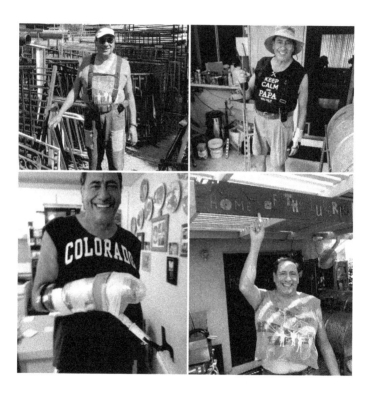

THE LUBERIG

L ubin: one of only three real names used in this book, and my dad's first name. Yes, it's uncommon to say the least, constantly prompting people to ask, "What is it again?" and "Did you say Ruben?" Even as I write this story, my spell-checker is furiously hurling red squiggles underneath each occurrence. Lubin Lubin Lubin Lubin!!

Jimmy Rig: a slang term meaning "to fix something regardless of how it looks or how long it lasts. Using any materials that are available to you in a creative way to make something work."

Luberig: a term I coined combining Lubin with Jimmy Rig and an apropos description of my youth. It can be used as a noun, for example, "This

Luberig pully system was used to help my dad hoist himself off the shitter after knee surgery," and as a verb, as in, "Dad Luberigged these elastic bands into some kind of boy-back-bra to help pull my shoulders back so I stop slouching." (Both, by the way, are examples of actual Luberigs.)

I'm convinced that my father has never actually purchased anything. Every item in his life, and my youth, has in some way been customized, enhanced, augmented, upgraded, reinforced, or fabricated from something else. Luberigged.

Dad's house is a museum dedicated to the power of the Luberig. His recliner chair, which showcases a swivel-armed leather cupholder (the exact size of a Budweiser bottle) and an extending retractable arm with a metal meal/laptop tray, belongs in The Smithsonian. Every item both inside his house and on his body has at one time or another been Luberigged. Every pair of shorts he owns were once pants. The headbands he wears while working outside were formerly t-shirts, and his arthritic hand braces are lined with old socks for added

cushion. Even the pockets on his sixty-year-old jeans have leather reinforcements sewn into them for durability. The kitchen boasts a series of hand-crafted clamps used to brace items in place while he acts as his own sous chef. And the self-closing reinforced backyard gate is one of his proudest creations, featuring a granite rock counterweight system.

Lubin's Luberigging has always fascinated and confounded me, while at times imperceptibly shaping the man I was to become.

Dad Luberigged our toys. Summertime camping trips meant it was time for my brother and I to make our own bow and arrow sets. Whittled sticks fastened with cut strips of rubber from an old bike tire created our bows. The arrows were smaller whittled sticks with carved nubs at the end to secure them to the rubber tire strips for accuracy. Arrowhead stone tips? Nope. "Just sharpen the fuckin' stick," he said. The embarrassment was palpable when the other kids' store-bought arrows

hit their targets, while ours usually hit the kid standing next to us.

Dad Luberigged my science project in elementary school. When other kids were showcasing their baking soda volcanos and cardboard cutout sundials, I was the only fourth grader who had expertly welded together a metal-tanked piston steam engine. When asked by my teacher how I had pulled off such an incredible feat, I stared at her with the blank face of a child born in a foreign country so rural that the English language didn't even exist.

He Luberigged finger splints from popsicle sticks to support the frequent broken fingers I experienced as goalkeeper of my soccer team.

He has Luberigged countless tools and mechanisms! After wrist surgery, and with his entire forearm casted, Dad created a prosthetic limb which attached to the cast and featured a spring-loaded clip at the end "to be able to hold stuff."

When we had rats in our garage, did we call an exterminator? Nope. Just Luberig it! My job in this operation, which took place in the middle of the night, was to quickly throw open the garage door, turn on the lights, and duck. The lights would cause the rats to momentarily freeze in panic, at which point Lubin, who was standing behind me with a BB gun, would take deadly aim. He was able to smoke at least two to three rats each time – with headshots, no less! A testament to his time in the Marine Corps, I suppose. Then, back to bed. The diseased vermin would dry in a tiny pool of blood, sticking to whatever surface they were killed. My detail was completed when the bodies were removed the next morning.

Dad even unwittingly Luberigged my college nickname. As luck would have it, Lubin also happens to be my middle name. Thanks, Pop! It's been the brunt of many jokes, nicknames, and questions throughout my lifetime, but the most lasting nickname came in college: Lubinmyass, LMA for short, coined by the brilliant nicknamer, Derek Tidwell.

Colorful and distinctive, Lubinmyass was the name that really stuck with my college buddies.

But the crowning jewel mined from the shit-tunnels of the Luberig caverns, and the culmination of a lifetime spent fixing things by looking around the room at what materials you had available, came in the form of a sleep apnea prevention mouthpiece Dad named "The Pivot Solution."

Dad suffers from sleep apnea and was a HORRIBLE snorer. As a teenager, I used to sneak out of the house by timing my movements to the rhythm of his snores, knowing that neither he nor Mom would ever hear me over the thundering bear in their room.

As fate would have it, years of piecing, welding, molding, testing, grinding, melting, improving, changing, and sculpting his mouthpiece produced a legitimate device! This is an actual excerpt from The Pivot Solution website, written by my dad:

"In 2008 I woke up in the middle of the night and thought, "tongue depressor!" I went to my kitchen

and started experimenting by bending kitchen spoons. The first tongue depressor was made from a kitchen spatula and other parts from ACE hardware. I removed the adhesive from clear gel foot inserts to cushion the metal on my tongue."

That shit is real. And it's about as Luberiggy as it gets!

Dad has patented "The Pivot Solution" mouthpiece and it has been clinically prototyped for eventual sale! An everlasting testament to the power of the Luberig!

THE BACON CHEESEBURGER

When I was a teenager, my first "real" job, outside of my paper route, was at Jack-In-The-Box. My starting and the current minimum wage at the time was a baller $3.35 an hour. Not enough to "make it rain" unless it was in change, but it felt like a ton of dough back then.

Our uniforms at "Jack," as we called it, included skintight dungarees with red piping down the legs. I believe these were the tightest pants a fifteen-year-old was legally permitted to wear in public. It took at least ten minutes to wrestle them on and I'd always come downstairs from the locker room sweating. Forget about crouching down in those bad boys, or you run the risk of bursting open like

a tube of ready-made croissant dough! My knees couldn't bend, and my nuts were hammer- locked in a full-nelson for the entire shift. Every shift. I had friends who used to come by the restaurant just to see me walk around in those pants.

The painted-on pants and the fat salary, however, weren't as attractive when you factor in the hassle of dealing with total assholes on a regular basis.

I never thought that people took their fast food *so* seriously, but they did. I also never thought that people were allowed to curse out a kid working at a fast food restaurant, but they did. It was the entitled angry fast food customer that proved to be the dirtiest part of this dirty job.

I've been called a "fuckboy," a "skinny dipshit," a "moron," a "dork," a "loser," and a "pimple faced shit-stick," to name a few. Clever, yes, but very hurtful and confusing to a young teen.

People threw money at me all the time, almost as if they were upset that I was charging them for the

food. One guy even threw syrup at me because he said his pancakes weren't hot enough.

The hardest-hitting diss, however, came from a frequent customer who once begged me to give her a discount. When I told her I wasn't allowed to give discounts and that I would get in trouble, she said "That's obvious, I could see from those pants that you didn't have any balls!"

I wanted to look down and see what she saw, or didn't see, because she clearly wasn't aware of the hammer-lock situation, but I was too embarrassed. Regardless of whether it was true or not, it still stung.

To make life at Jack even more difficult, the owner of my restaurant, Phil, was notoriously cheap.

We were the franchise that ALWAYS opted out of the advertised TV promotions and deals. "Sorry, we're not participating in that special" is a phrase we employees used often, and the customer response was ALWAYS angry and abusive.

Phil was so cheap in fact that he repeatedly instructed us to short the customers' ketchup requests. (This was long before the days of ranch dressing, thankfully) So if the customer requested ketchup, we were directed to ask, "How many would you like?" Phil claimed that "Everyone asks for more ketchup than they really want or need," so we were told to ALWAYS give the guest one less ketchup than requested. (Secretly, I'd always hoped that someone would ask for a single packet of ketchup, only to find us awkwardly staring at each other as I shorted their request.)

One time, an older customer who was eating inside the restaurant came to the counter and asked for ketchup.

"How many would you like, sir?" I asked.

"Gimme three," he responded.

When I laid two packets of ketchup on his tray, he looked up at me and asked, "Do you know how to count, or are you a little fucked in the head?"

I did know how to count, and I felt like an obedient moron.

There *was*, however, an unspoken way that we, the abused, could express our contempt. A way to get even with the mean people. A way to fight back while under fire. We could fuck with their food.

Pickle juice in the soda was popular for the low-level offenders. A "forgotten" slice of cheese on a cheeseburger, an extra well-done patty, sauce on a "no sauce" order, or a super-salty batch of fries were also used for the petty crime customers.

The bigger pricks might get a couple glugs of mayo-onion sauce in their vanilla shake.

The galactic asswipes may or may not have been given a burger patty that kissed the floor or even a bit of extra secret sauce, from my mouth.

I got my little brother a job at Jack, from which he was almost immediately fired for throwing a handful of liquid creamer packets at a super-rude

fucker in the drive thru. He hadn't learned the subtleties of the game yet.

One day, another colossal bastard in the drive-thru mercilessly berated my coworker over the loudspeaker. This was before the days of headsets, and I, who was on the grill that afternoon, overheard everything. This guy was a real piece of work.

I was actually afraid to do anything horrible to his food, because he was *such* an angry dick. Instead, I wrapped his bacon cheeseburger seven times. It was the size of a soccer ball by the time I was finished. It was like the Russian nesting doll of burgers.

I put the burger ball in an oversized bag and laid a bunch of napkins on top to hide it. He snatched the bag from my coworker and peeled out of the parking lot, only to peel back in twenty seconds later.

Prick-boy came thundering into the restaurant, spotted me on the grill, and full-strength CHUCKED the burger at me! I ducked the shot as he hollered, demanding to see the manager.

Thankfully, the manager, also a teenager, was a close friend of mine; he was also Phil's son. Burger-prick was not happy. When he finally stormed out of the restaurant, I inspected the sandwich he threw at me. He had opened four wrappers before losing his shit! I wish I could have been in the car for that.

THE MAGS

On a beautiful weekend in the summer after eight grade, my friend Jake and I were riding our bikes through the neighborhood. No agenda, no plan to speak of, but what waited for us at the end of this roll-about would prove to be a game-changer.

A sign advertising the first of a two-day garage sale directed us to a house nearby. Maybe they were selling some cheap cool shit, we thought, although I'm quite certain we didn't have more than three bucks between the two of us.

We pulled up to the house, dropped our bikes on the lawn and followed the cardboard arrows that directed buyers through the side gate into the back-yard. The sale items were showcased on tables that

lined the entire yard. A stark contrast to the typical sales that featured piles of shit scattered all over the ground, as if the garage had actually puked on the driveway.

This sale was pro-status, which gave us the feeling that there may be some sweet finds to be had. We made the rounds, Jake and I, moving from table to table – faking interest at the kitchenware's, glancing at the clothing, and moving straight past the broke-ass furniture on the lookout for something cool.

The next table was stacked with books and magazines. No thanks. I kicked my pace up a step to get beyond the sleepy book table when something in my pre-historic nature pulled my head back to the table. A sweeping glimpse of cleavage sent a surge of lightning through my hairless body.

Involuntarily, my legs hit the E-brake and I turned in disbelief. Before me lay a pile of nudie mags so massive there must have been a picture of every

naked woman on the planet. It was ALL the women. All of them. Naked. I heard music.

It's worth mentioning that this was LONG before the click of a remote control got you full frontal on pause, or a few keystrokes on the computer brought hardcore porn to the party. The closest we'd come to images of naked ladies was a spread about the tribes of Papua New Guiney in *National Geographic*, and even that didn't quite hit the spot.

This was the best thing I had ever seen. And it was for sale.

Unfortunately, neither Jake nor myself had the stones in our bald sacks to ask if we could purchase these treasures, lest word got back to our parents somehow. There had to be another way. So we left the garage sale, and we plotted.

That afternoon, we came up with a plan so devious yet so inspired that it seemed worthy of us putting our lives on the line. Jake got permission to spend the night at my house, and we waited for lock-up and lights out.

Within a couple hours of bedtime, I could hear my dad snoring upstairs. The coast was clear. We timed our movements with each of Dad's apnea snorts, easily making it to the front door. Two more snoring jags and we were out the door. We jumped on our bikes and silently rolled down the dark street.

A well-rehearsed plan made it possible for us to execute without any conversation or confusion. We parked our bikes two houses down from the sale house and walked to the concrete block wall that led to the backyard. Once at the wall, Jake laced his fingers together and gave me a nod. I stepped into his hands and hoisted myself to the top of the cement wall. Looking down into the backyard I could see the pile, glowing. I lowered myself into the yard, tiptoed to the magic table, and grabbed as many magazines as my two hands could carry. I walked back to the breach point and began stacking the magazines on the wall. They disappeared as fast as I could set them down, with Jake on the other end pulling our bounty down to safety. I bounded back up and over the wall, took my share of the loot and we scurried back to our bikes.

It worked! It actually worked! The exhilaration was indescribable as we biked back towards my house. The possibilities seemed endless and the take was large! It felt as though we had enough jack-stack material to last four lifetimes.

The darkness of a three-a.m. heist made it impossible to immediately enjoy the fruits of our thievery, so we devised yet another plan. We would stash the magazines in two sets of dense bushes at the end of my block, keeping them both hidden and protected. Come morning, we planned to retrieve the stockpile and start our new lives.

Safely home and undetected, we could barely sleep. The boner of anticipation was far too strong.

In the morning we made our way back to the drop site at the end of my block.

As we approached, the bushes appeared to be sparkling, like a pot of gold at the end of an erotic rainbow.

Turs out, they were just wet. The electric sprinkler timer must have been rigged to the "karma" setting

because every single magazine was so thoroughly soaked that trying to pull them from the dense bushes turned them to confetti. The one thing our brilliant plan hadn't considered: the fucking sprinklers. We were devastated.

THE HOUSEKEEPING

I can count on one hand the number of times I've puked as an adult.

That said, when it DOES happen, it's quite a scene for one simple reason. I am THE loudest and most violent barfer I've ever known.

It's actually a bit embarrassing because for as much as I've tried, I literally can-NOT control the volume of my retching. It's a primal barking shriek that I've never been able to imitate and a body thrashing that probably looks like those inflatable tube-men outside car dealerships.

On two different occasions, I've ralphed myself unconscious and woken up pinned between the

wall and toilet. And on this particular occasion, the unlucky woman from hotel housekeeping… well, I think I broke her brain.

Last weekend, on a business trip to Seattle, I got hit with a gnarly case of food poisoning. The alleged culprit: a grilled chicken sandwich from the local pub around the corner from our hotel.

This was a full-service poisoning. Sweats, hot flashes, aches, doubled-over cramping, the works. But I was trying desperately to avoid the porcelain.

The seven-a.m. alarm sounded. I showered and dressed, hoping to shake it off. But no luck. It was go time.

Seconds later, the inevitable occurred. An exorcism in my hotel bathroom. The cock-a-doodle demon in that fuckin' chicken WRECKED me!

It was the loudest and most ferocious heaving to date. It sounded like a crime was being committed. I tried to control the volume, but it only made the wailing louder. Have you ever seen the

video of the guy who was testing a dog's shock collar but couldn't stop shrieking from the pain, which only continued increasing the intensity of the shocks, making him scream even louder? It was like that.

When I finally regained my composure, and will to live, I stood up, washed up, and headed out the door to work.

When I opened the door, I noticed a housekeeping cart in the hallway, directly across from my room. Thinking little of it, I stepped out into the hallway and quickly noticed the cleaning lady, hiding behind the cart.

She was crouching down, shielding herself from the chaos she'd heard in my room. Her face was panicked and disbelieving, with one hand covering her open mouth. It was an actual human being that had emerged from my room, and I could see she was struggling to make sense of it.

"I'm so sorry," was all I could think to say.

"Ay, Dios mio," she replied.

"I'm so sorry, I'm sick." I rubbed my belly, unable to think of the universal sign for blowing chunks.

"Oh my God, I think you die," she responded.

"No, I no die. I'm sorry. Please, you don't have to clean my room today."

"Okay, no clean, thank you, I scared," she admitted.

"I understand. I'm sorry. I'm just a really loud…ya know what, forget it. I'm just really sorry."

THE FLEEDINIMA

When I was seventeen I had a job at a large chain grocery store. Shortly after clocking in one morning I was walking toward the front of the store when I noticed an older gentleman flagging me down. I approached him and asked, "How can I help you?"

"Where can I find your fleedinimas?" he inquired. Having absolutely no idea what he said, I ask him to repeat the question.

"I'm lookin' for your fleedinimas," he said in a hushed but stern tone.

I was stupefied. He was speaking English and yet it was impossible for me to understand what the hell he was asking for.

"I'm really sorry, sir, can you tell me one more time what you're looking for?"

"A FLEEDINIMA!"

Now I was screwed. I had no clue. He was getting more and more pissed off every time he was forced to repeat himself and my embarrassment was rising at the same rate.

Then I thought, If I stare directly at his lips, I can figure out what the fuck this guy wants. So I zoomed in on his mouth and pleaded, "I'm so sorry sir, just one more time?"

My eyes were deadlocked on his lips as he said, "A FLEEDINIMA!"

I've got nothin'. Nada. Zero. Finally, I came up with a brilliant idea. "Can you tell me what it's used for? Maybe that will help me tell you where to find it."

He looked me dead in the eyes, extended the index finger of his right hand and started thrusting it up towards the sky shouting,

"YOU STICK IT UP YOUR ASS!"

Message received. Although I had no idea what he was actually looking for, I did know that all the ass stuff was on aisle eleven, which is where I directed him.

I watched as he pulled a box from the shelf, unable to believe that our grocery store actually sold a product that someone needed to stick up their butt. Of course, at that age I didn't know that anyone stuck anything up their stink-tunnel for any reason at all!

Later that day, I returned to the spot to investigate. It was then I learned there was indeed something called an enema, and the directions on the box instructed the user to insert this thing into their anus! ("Ha,ha… he said anus" I thought to myself.) I also learned that there was a company called Fleet that made them. A Fleet enema. Not a *fleedinima*.

Now I understood why as the man walked past me at the checkout line, he'd leaned towards me and confided, "It's not for me, it's for my wife."

THE FINGER

My dad has "working man hands" – Thick, strong, rough to the touch, with a lifetime of use and abuse built right in. Although a combat veteran of the Vietnam War, it was instead from his twenty-five year career as a gas pipeline welder and construction foreman that his hands were carved.

Dad's chosen method of punishment, and that of many parents in the 70s, was to hit me and my brother with his belt. The logic behind this was Dad's fear that he'd really hurt us if he used his hands. My therapist begs to differ, but I digress.

Dad's hands have been many things to me throughout my life, but my relationship with the index finger of his right hand is a very specific one.

Weekend yardwork was the norm, and I always looked forward to lunchtime, when the family would break for chow on the front lawn. Hot pastrami sandwiches from the local fast food joint, Omega Burger, was my absolute favorite.

One particular Saturday when I was eleven years old will always stick out in my mind. I was wolfing my sandwich down a little too aggressively and a giant long piece of fat got stuck in my throat. I knew immediately that this was very bad. I wasn't even gagging on the pastrami; I was *for- real* choking to death on it. Unable to breathe, I clutched my neck and looked up at my family for the last time.

Dad stopped chewing and just stared at me for a few seconds. Clearly, he wanted to give it a few beats to see if this was really an emergency, or just his son being a "dramatic pansy."

When it was clear that I was unable to recover, he lunged across the lawn, grabbed me by the back of the neck, and shoved his right index finger all the way down my throat.

I clearly recall the girth of his meaty sausage finger filling the void of my mouth, and the delicate smooth tissue of my young throat being mauled by his leathery digit. I tasted gasoline and rage.

In that moment it became painfully clear that we'd unearthed a hidden talent: the ability to deep-throat like a professional porn star. Much to my surprise, I was able to easily accommodate Dad's "hamburger-helper" finger pushing further into the depths of my body without a single gag.

My siblings sat in petrified shock as Dad fingered their big brother's throat on the front lawn during lunch.

Incredibly, his finger resurfaced with an enormous strand of pastrami fat dangling from the tip. I was saved.

Fast-forward thirty years.

Dad and I were having a discussion about the details of his will, as I'd been appointed executor of his living trust. All the necessary and certified

documents pertaining to the will were housed in his computer, which could only be unlocked using a fingerprint scanner. Dad's right index finger was required in order to access the computer and its files.

In a hushed and serious tone, Dad leaned in towards me and said, "Son, when the time comes, you're gonna need this finger." as he extended and held out his right index finger. The same finger I had deepthroated as a child. He continued, "So, you're gonna have to come to wherever my body is and just take it. Just cut the fucker off, son, 'cause I don't need the fuckin thing" was his exact instruction.

I paused and stared at him for a few seconds, contemplating the suggestion, then said, "Dad, it's a laptop."

When it finally dawned on him that his computer was portable, and after I told him I could just bring it to his finger, he said, "OH. Oh yeah, okay, just do that then."

THE BLOCKBUSTER

If you're old enough to remember Blockbuster video stores, you're my people. If not, here's a brief introduction.

Long before the internet, there were actual stores where people would go to physically rent movies to bring home and watch – at first in VHS tape form, and later down the road, DVD. The actual process of renting these movies, however, required an etiquette that was invariably the same, regardless of which Blockbuster you frequented.

The store was lined, wall to wall, top to bottom, row by row, with the entire inventory of movie offerings. They were in alphabetical order, so when you walked in the store, immediately to your left

were the movies beginning with a numerical title or the letter "A," continuing on through the alphabet as you walked the perimeter.

If you knew what you were looking for, you could dart straight to it. If you were browsing, however, you'd begin a familiar dance that I've dubbed "The Blockbuster Shimmy."

The Shimmy occurs as you face the wall of movies, scanning up and down, side to side, and "shimmy," or sidestep, to the right as you move from shelf to shelf. It occurs organically, and often without awareness of what's happening in front or to the side of you. The annoying part was when some derelict decided to do their shimmy in reverse from Z to A, causing the inevitable crossover at some point.

On this particular evening, I, my girlfriend, and her sister entered our local Blockbuster and began our shimmy. Though we were moving at different paces, it was easy to spot my girlfriend's black leather jacket and blue jean outfit to confer about potential rentals.

I should preface what happened next by saying that a playful open-handed spank on the posterior was a common act of affection between myself and my girlfriend.

As we got deeper into our shimmy, scanning high up on the shelves, I spotted a potential winner. My girl was blurred in my peripheral vision but standing slightly to my right.

"Hey babe, how 'bout THIS one!?" I asked as I five-starred my girlfriend's bum with the usual spirited enthusiasm. Typically, my hand would spring back from her can with the expected bounce of an athletic girl in her early twenties wearing tight jeans. This time, however, something was amiss.

As my hand buried itself into my girl's dumper, that familiar spring was missing. I was in foreign territory. Soft, much older, foreign territory. I gave a squeeze to find my bearings, like a man searching for his flashlight in a blackout. My hand, however, was lost in a saggy handful of unknown ass-meat.

I pulled back and looked down into the face of a total stranger. A stranger who had shimmied her way in front of me without my notice. A stranger who happened to be wearing blue jeans and a black leather jacket. A stranger who would hear another stranger behind her shout, "Hey babe, how 'bout THIS one!?" before rocketing his hand into her nonconsenting butt cheek.

The poor woman standing in front of me turned around with a look on her face that I will never be able to fully describe, but you can probably imagine it.

A moment passed with her and I locked in an open-mouthed devastation stare. I threw my hand over my lock-jawed mouth.

"OHMYGODOHMYGOD I AM SO SORRY!" I pleaded, "I THOUGHT YOU WERE MY GIRLFRIEND!"

She paused a moment and asked, "Where is this supposed girlfriend of yours?"

In a panic, I quickly scanned the area for proof. Turns out, my girlfriend and her sister had witnessed the smack heard 'round the world and were on the ground in hysterical laughter. I pointed to the floor to evidence the outfit and begged the stranger to believe me. She scanned back and forth between me and the girl on the floor with a deliberating scoff.

"Okay, I guess" was all she said.

A shower of relief poured over me as a surge of blood coursed back into my extremities. My stomach was given permission to be seated again, as my panicky nuts peaked out from my colon to see if the coast was clear. That's the moment I heard the stranger holler across the Blockbuster, "Hey honey, this guy just smacked me in the ass 'cause he thought I was his girlfriend!" (cue nut retreat)

I didn't turn to see the man. The only thing I heard from behind me was his confused response of, "What?!"

I stood there waiting for the man to come collect his vengeance. "Okay," I thought to myself, "Some dude is gonna come kick your ass real quick. It's somewhat deserved, so just let it happen. I mean, don't be the guy who just stands there while some dude beats six colors of dog shit outta you in front of a Blockbuster audience, but let him get a few good shots in and put an end to it." I swear to you, this all ran through my mind in that split second.

As quickly as that thought escaped me however, the moment had miraculously diffused. No one was kicking my ass, the shimmy had commenced, and life appeared to begin again. I immediately retreated to the car in total disbelief. I don't remember if the girls rented a movie that night, if we watched it, where we watched it, or if I even enjoyed it. One thing was certain, though: we'd never forget what happened in that store.

To this day, I deeply regret not going back into that Blockbuster to beg for the video surveillance footage. Of course, it would have been better if the husband kicked my ass.

TOOTHLESS

THE X2

To appreciate the fake face on the left, you have to understand exactly how real the *real* face was on the right.

The photo on the left is one of those "I know exactly where the camera is, so I'm gonna be the first person to make a stupid face when they take the shot, and it will be hilarious and original." Fail.

It was, however, an opportunity to showcase the ugliest face I could make. Clearly, I was capable of much more, which brings me to the photo on the right. Not only did I have zero idea where the camera was, but if you asked me in that moment I wouldn't have been able to tell you what the fuck a camera was!

The ride was called X2. That picture was taken the instant the ride jerked in an unrecognizable direction that created a horrifying sensation I had never experienced.

In that very moment, my eyeballs dislocated from my skull, from each other, and operate independently to this day. There were unmentionable things happening in my boxer briefs. My jaw dislocated like a python in order to make room in my mouth for the utterly terrified yelping that would follow. I became fluent in Yiddish. My chins fused together to form one long turkey snood, and the shrieking jarred my dad's kidney stone loose from forty-six miles away. My arms fused themselves in that position for one hundred and ninety-eight days, earning me the nicknames "Praying Mantis" and "T-Rex." Brutal.

TOOTHLESS

THE SISSY

I farted on my dog this morning.

Not on purpose, but not exactly by accident either.

You see, she jumped into bed with us at zero dark thirty and curled up right beneath my stink-turret. Unfortunately for her, there was a round in the chamber and the safety was off.

My wife was sound asleep, I had the shot, there was no danger, so I took it.

If you knew me at all, you'd know how deeply I love my dog, Sissy.

When I went "guns-hot" on her, she didn't even flinch.

Turns out that love is mutual.

I'm sorry, Sissy. I'd call "fire in the hole," if only I thought you knew what it meant.

TOOTHLESS

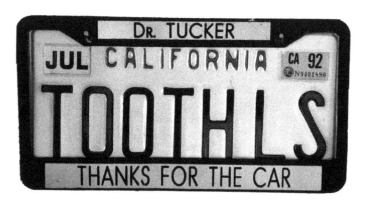

CLOSING

To Dr. Tucker, thank you, for making the title of this book a no-brainer. Little did I know what lay ahead when my mom got that call from you back in 1982. She was crying then, and there would be more tears to come, but in the end, I believe the experience may have been worth all the stories, and all the laughs.

Oh, and I'm sorry for the asshole-ish license plate. I was barely eighteen years old and thought it was hilarious. I had to remove that plate from my car before it was repossessed by the bank for non-payment, so I guess you had the last laugh. I hope this book leaves you smiling down from wherever you are. Know that I'm smiling too, just with one less tooth.

CONNECT WITH
THE AUTHOR

For all inquiries, social media links, author
and book information, please visit
www.toothlessbook.com

CPSIA information can be obtained
at www.ICGtesting.com
Printed in the USA
FSHW011001290921
85108FS